Artist's Shuffle
My Dichotomy
2015-2017

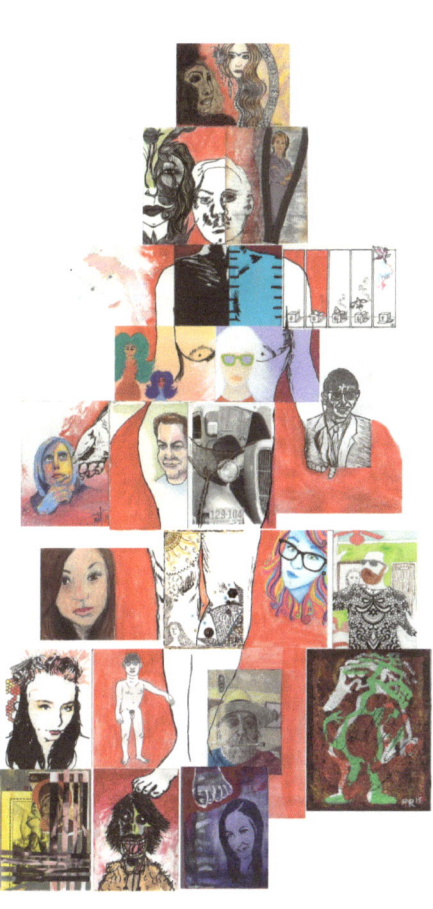

Artist's Shuffle: My Dichotomy is an international collaboration with Autumn Steam. Copyright 2017 by Autumn Anglin (Autumn Steam). All rights reserved. No part of this book may be used or reproduced in any manner without written permission. For information email autumn@autumnsteam.com.
FIRST EDITION
Designed by Autumn Steam
ISBN-13: 978-1542968706
ISBN-10: 1542968704

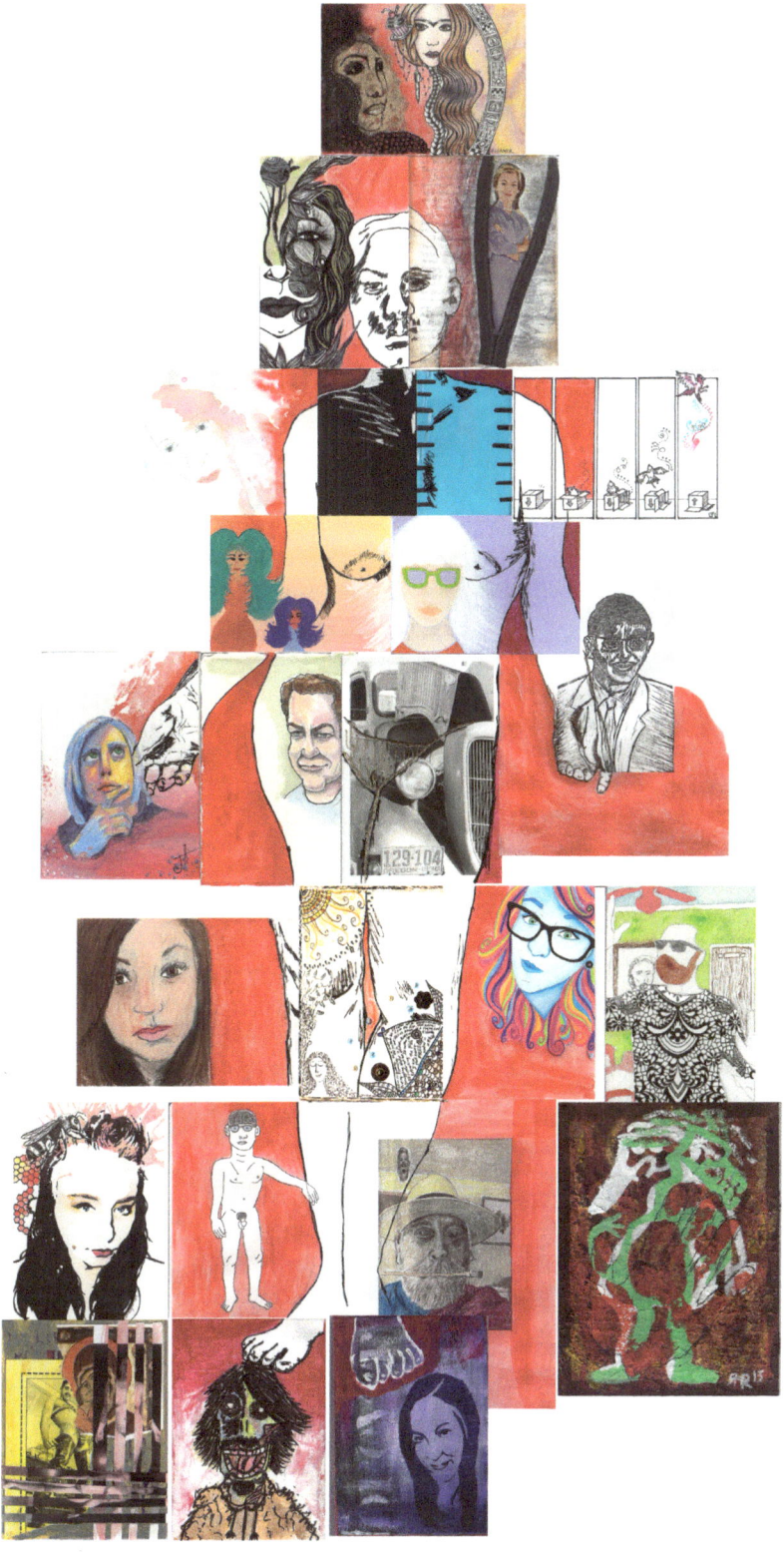

DICHOTOMY

NOUN
di·chot·o·my \dī-ˈkä-tə-mē\

PLURAL **DICHOTOMIES**

1: A DIVISION INTO TWO ESPECIALLY MUTUALLY EXCLUSIVE OR CONTRADICTORY GROUPS OR ENTITIES ⟨THE DICHOTOMY BETWEEN THEORY AND PRACTICE⟩; ALSO : THE PROCESS OR PRACTICE OF MAKING SUCH A DIVISION ⟨DICHOTOMY OF THE POPULATION INTO TWO OPPOSED CLASSES⟩

2: THE PHASE OF THE MOON OR AN INFERIOR PLANET IN WHICH HALF ITS DISK APPEARS ILLUMINATED

3:
 A : BIFURCATION; ESPECIALLY : REPEATED BIFURCATION (AS OF A PLANT'S STEM)
 B : A SYSTEM OF BRANCHING IN WHICH THE MAIN AXIS FORKS REPEATEDLY INTO TWO BRANCHES
 C : BRANCHING OF AN ANCESTRAL LINE INTO TWO EQUAL DIVERGING BRANCHES

4: SOMETHING WITH SEEMINGLY CONTRADICTORY QUALITIES ⟨IT'S A DICHOTOMY, THIS OPULENT RITZ-STYLE LUXURY IN A PLACE THAT FRONTS ON A BOAT HARBOR — JEAN T. BARRETT⟩

DICHOTOMY AND FALSE DICHOTOMY
THE TWO MOST COMMONLY USED SENSES OF DICHOTOMY ARE EASILY (AND OFTEN) CONFUSED. THE OLDER ONE REFERS TO THE DIVISION OF SOMETHING INTO TWO GROUPS THAT OFTEN ARE MUTUALLY EXCLUSIVE OR CONTRADICTORY (AS IN "THE DICHOTOMY BETWEEN GOOD AND EVIL"). LIKE TRICHOTOMY (MEANING "DIVISION INTO THREE PARTS"), THIS SENSE DENOTES SEPARATION INTO DIFFERENT ELEMENTS, BUT IT ADDS THE CONNOTATION OF OPPOSITENESS. THE NEWER SENSE OF DICHOTOMY DENOTES A THING THAT APPEARS TO HAVE CONTRADICTORY QUALITIES, SUCH AS A LEMONADE STAND FOUND IN A WAR ZONE. DICHOTOMY IS FREQUENTLY FOUND IN THE COMPANY OF THE WORD FALSE; A FALSE DICHOTOMY IS A KIND OF FALLACY IN WHICH ONE IS GIVEN ONLY TWO CHOICES WHEN IN FACT OTHER OPTIONS ARE AVAILABLE.

ORIGIN AND ETYMOLOGY OF DICHOTOMY
GREEK DICHOTOMIA, FROM DICHOTOMOS —SEE DICHOTOMOUS

FIRST KNOWN USE: 1610

"Dichotomy." Merriam-Webster.com. Merriam-Webster, n.d. Web. 5 Feb. 2017.

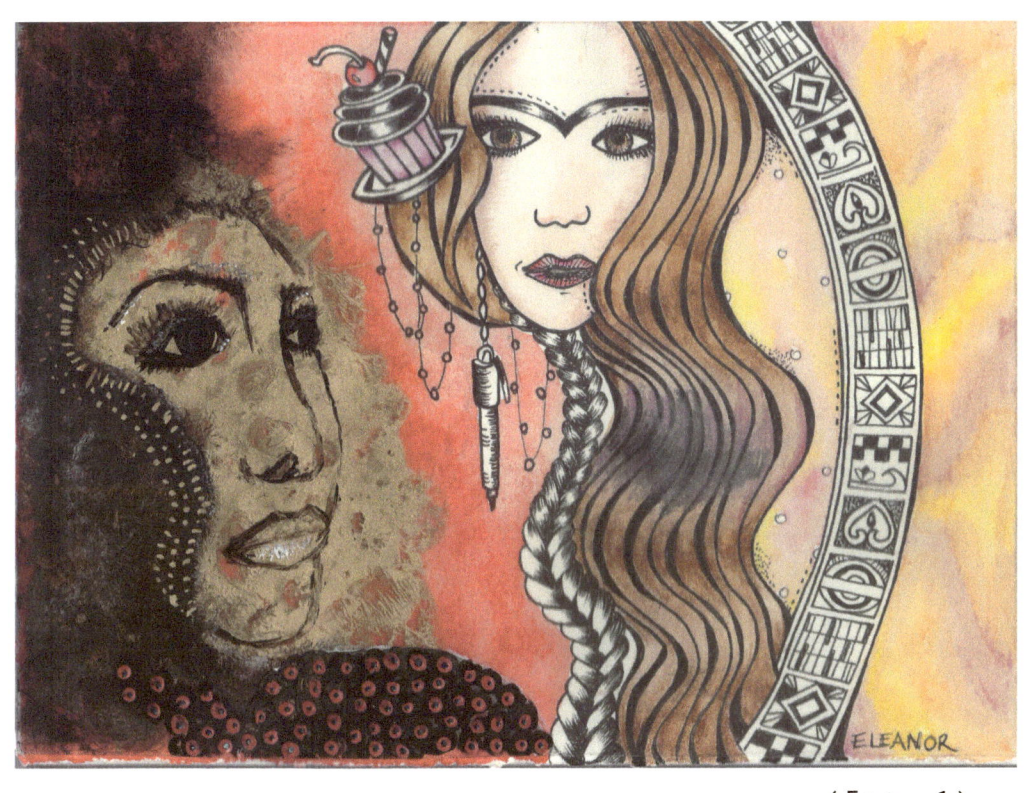

(Fig. 1)

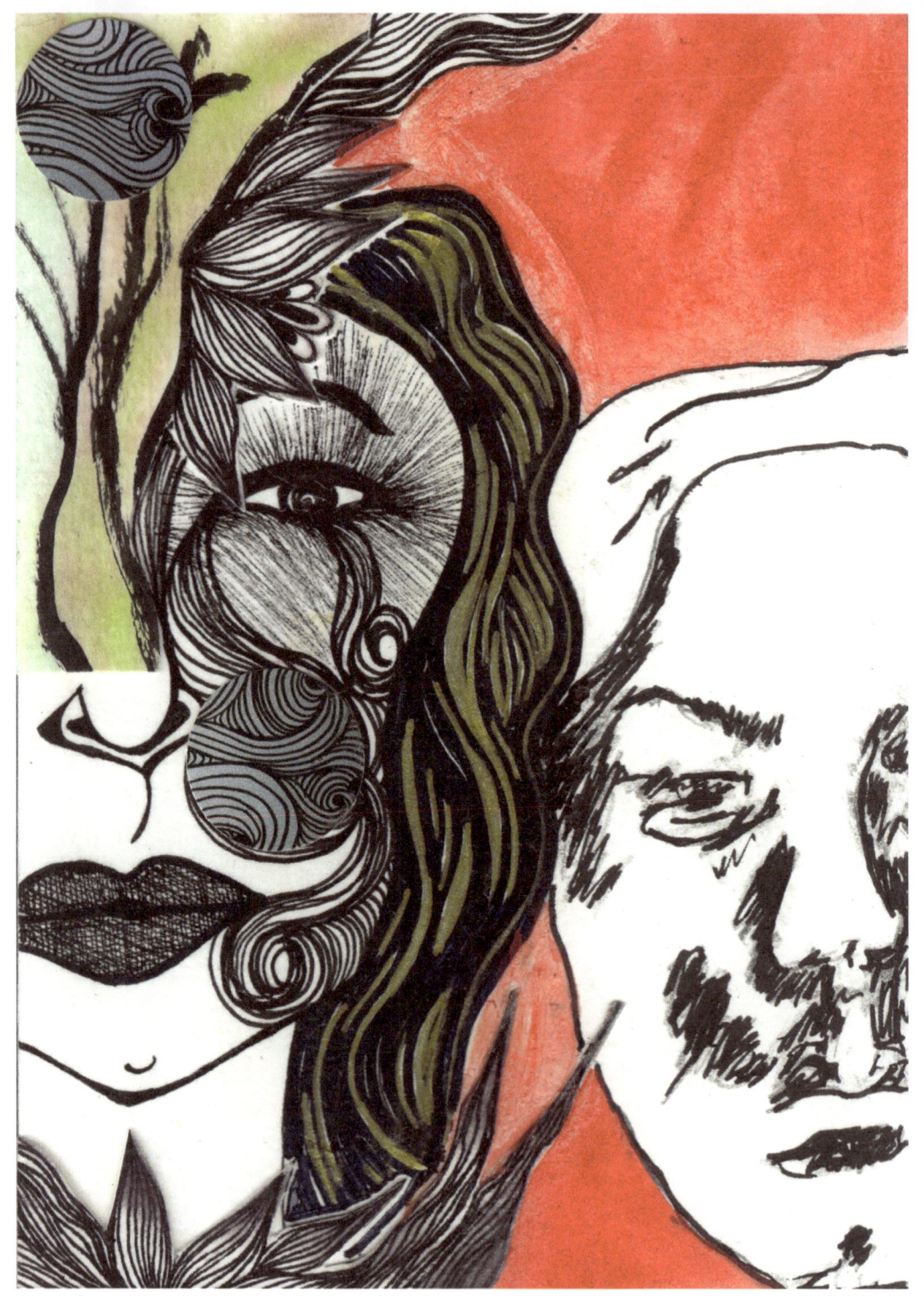

(Fig. 2)

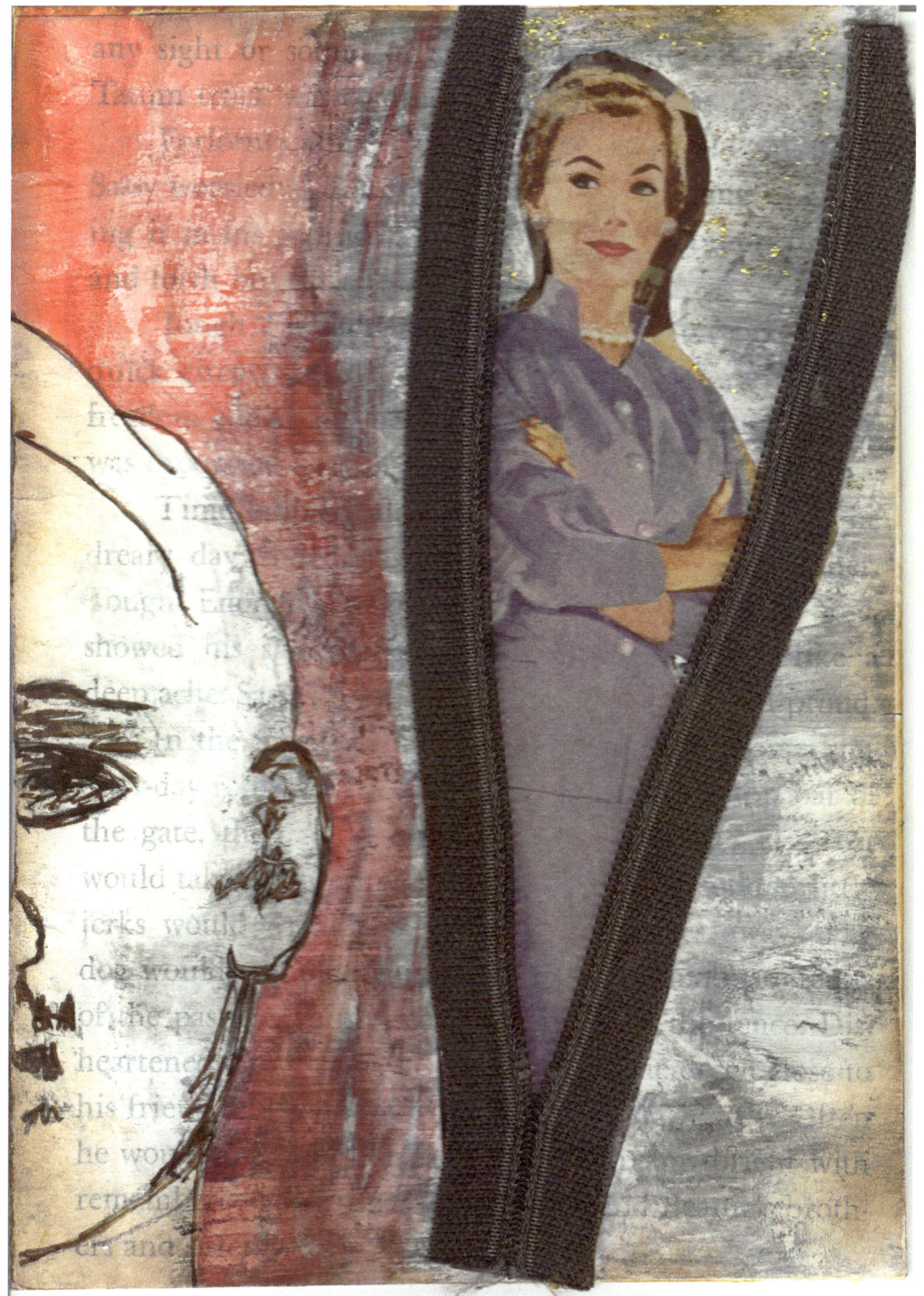

(FIG. 3)

(FIG. 4)

(FIG. 5)

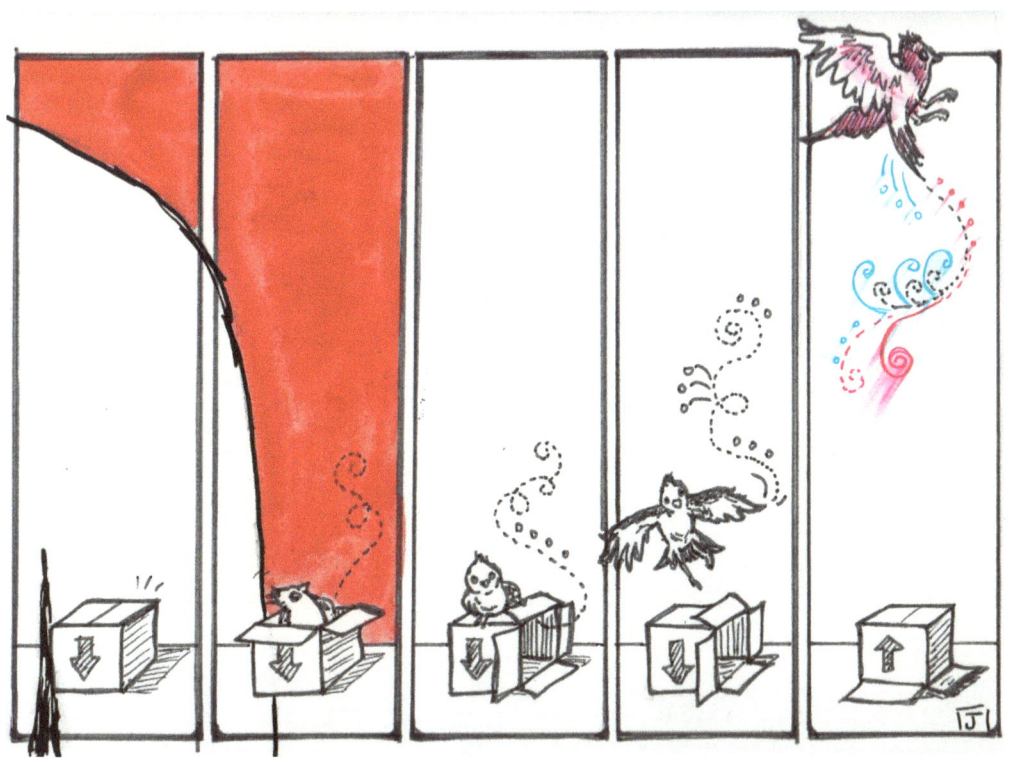

(FIG. 6)

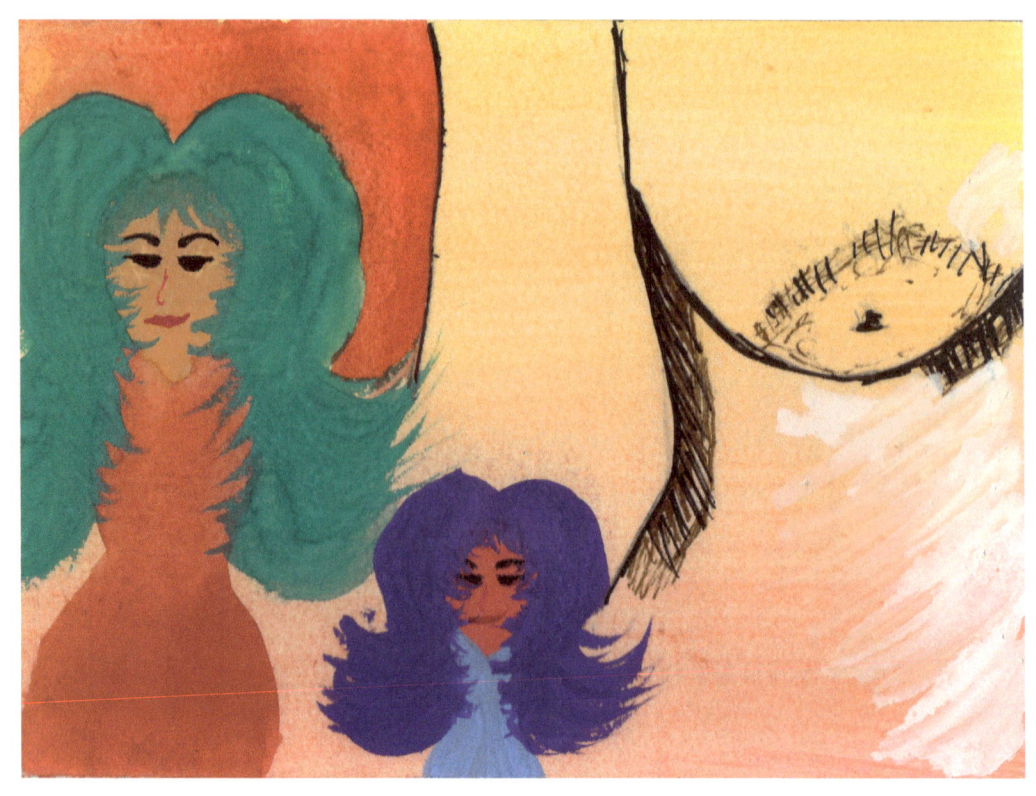

(Fig. 7)

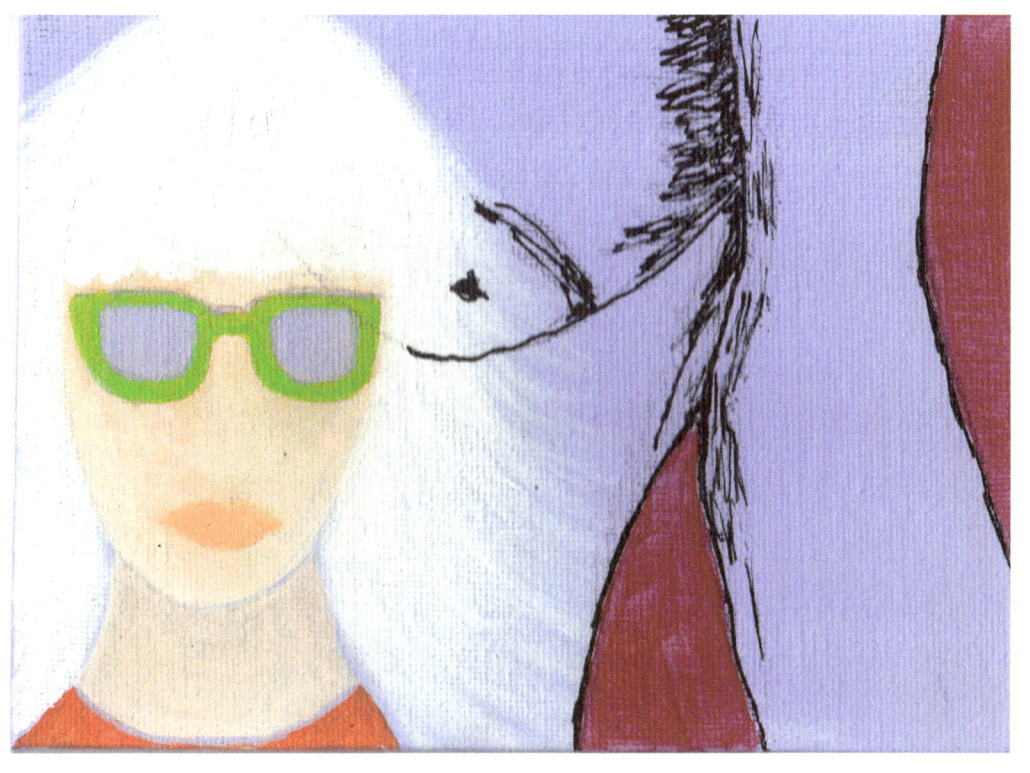

(FIG. 8)

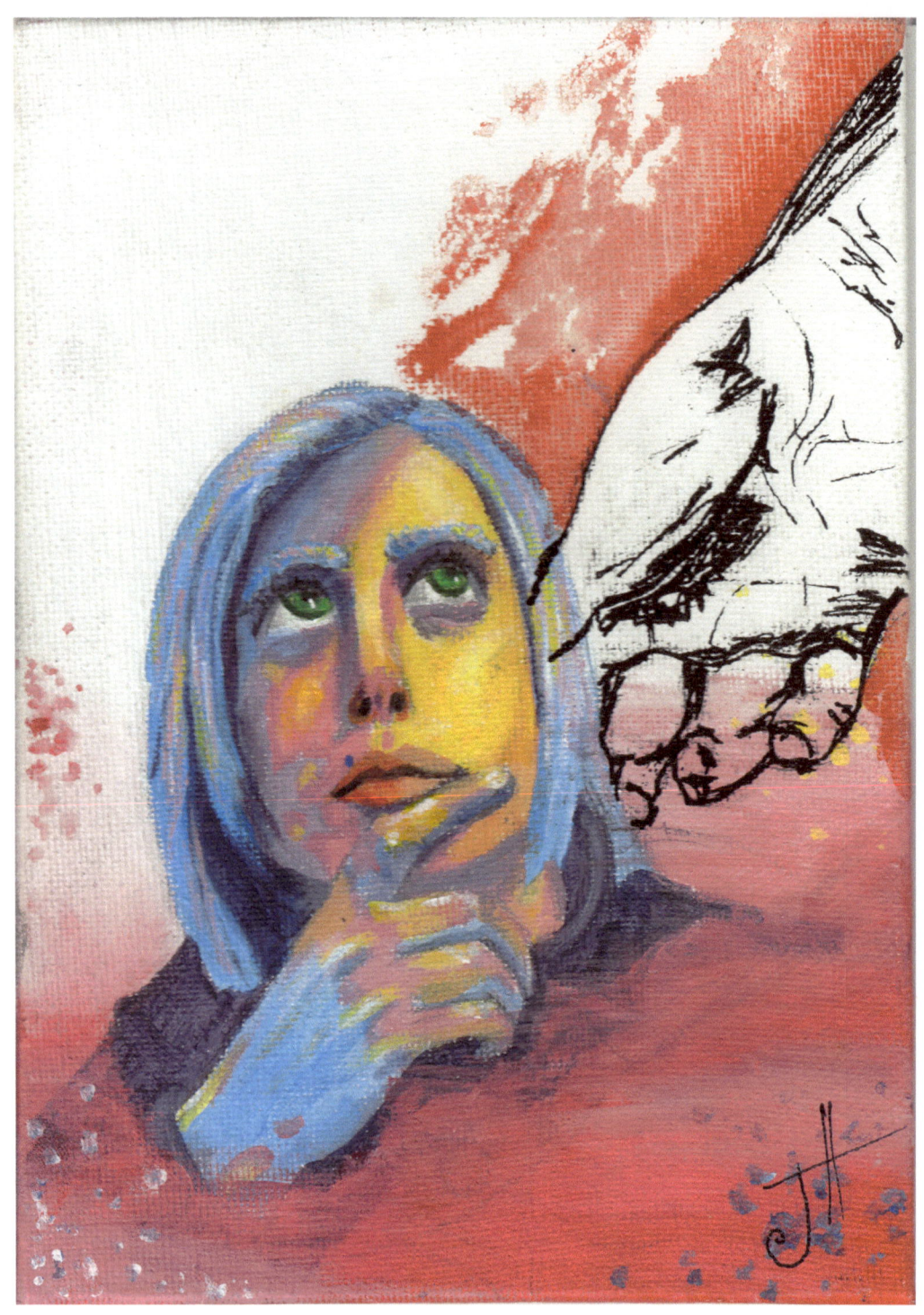

(Fig. 9)

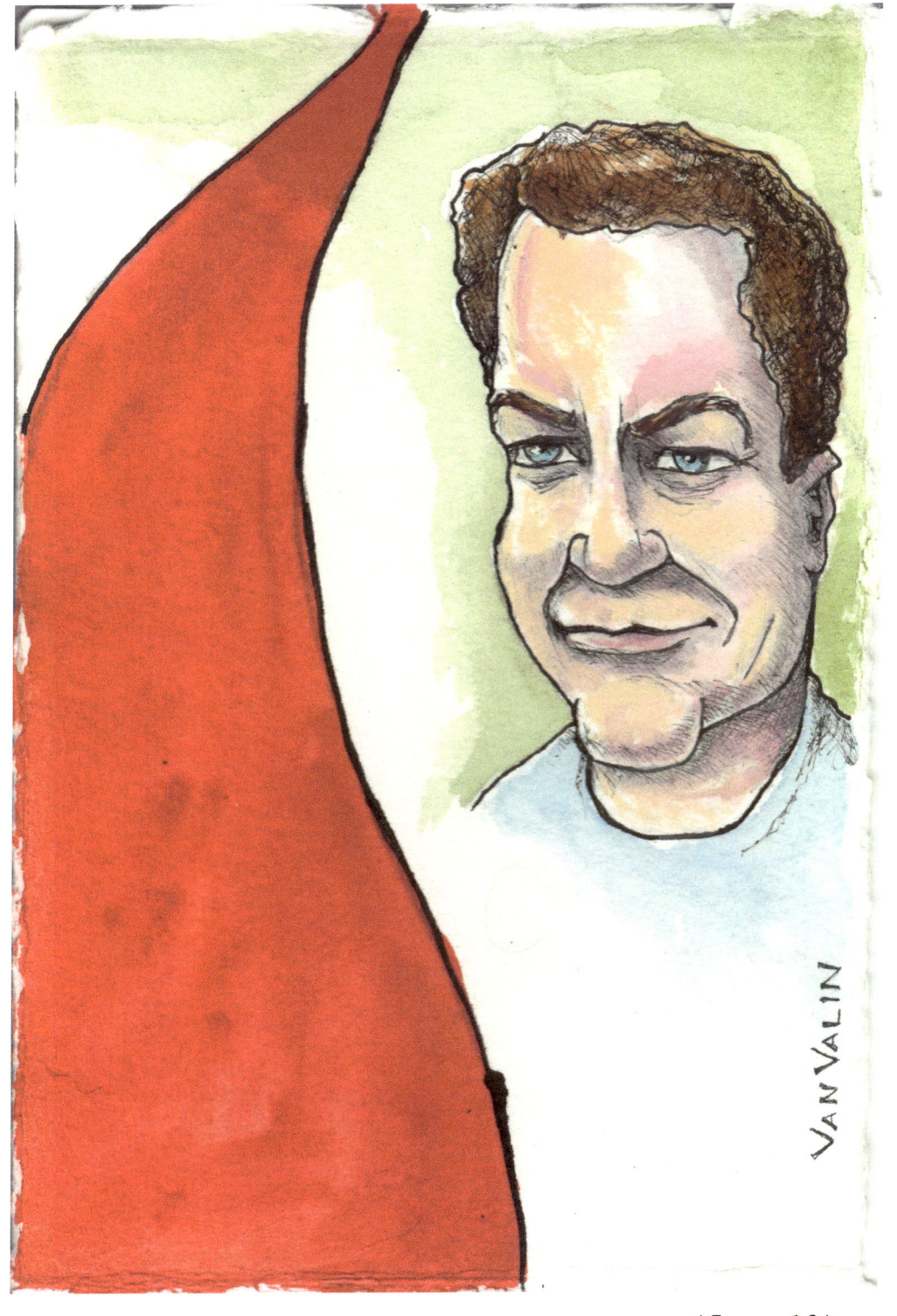

(Fig. 10)

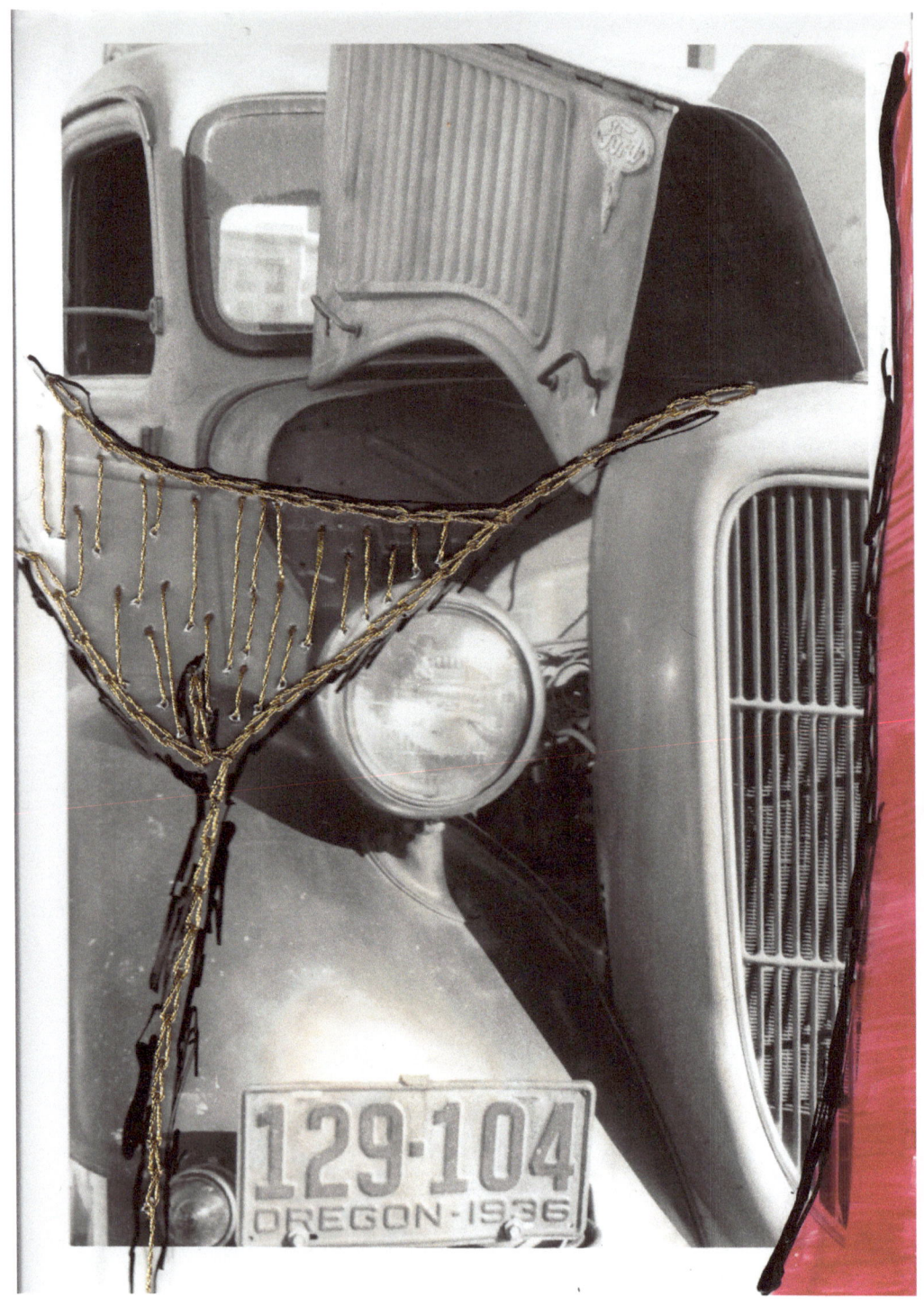

(FIG. 11)

(FIG. 12)

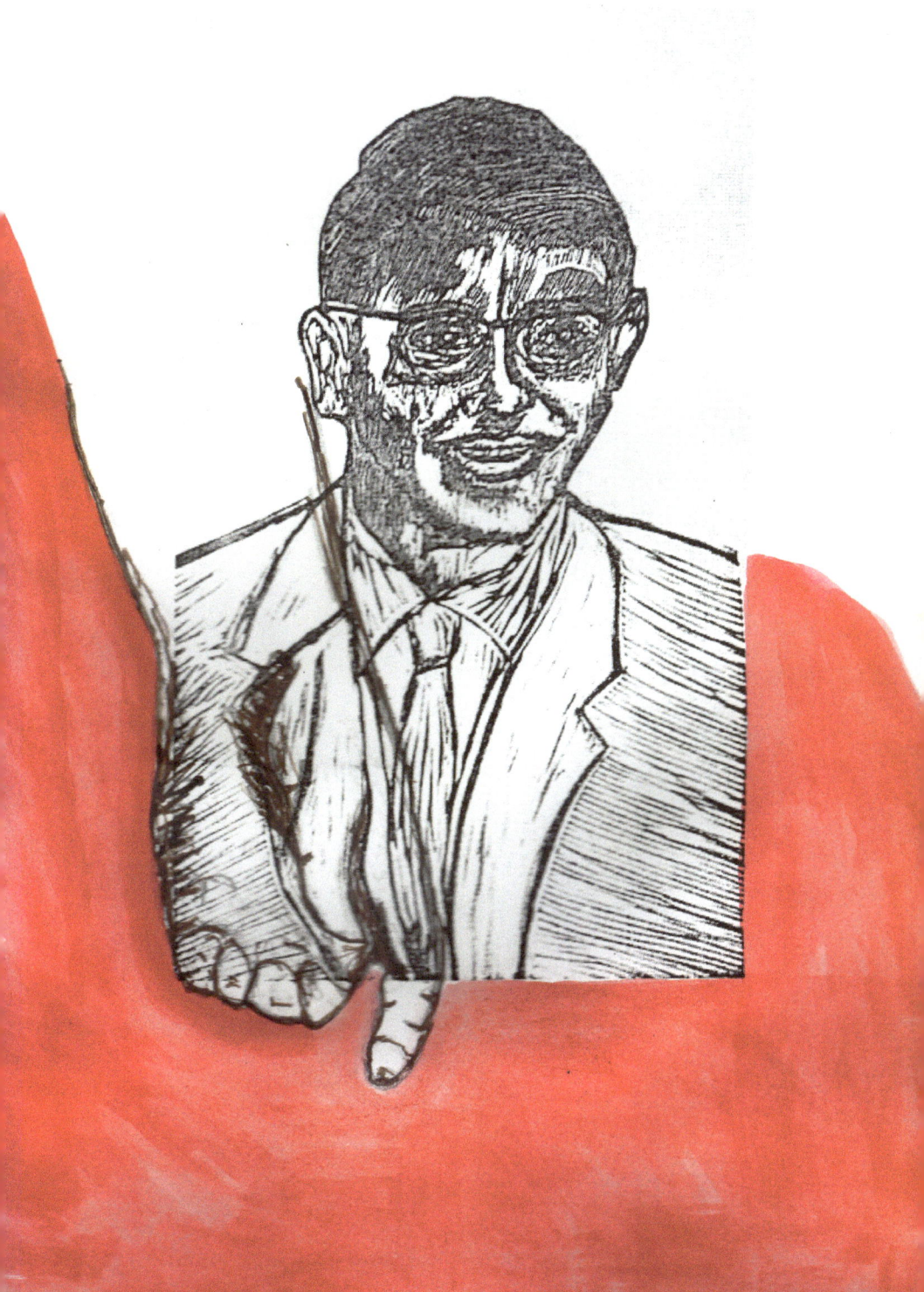

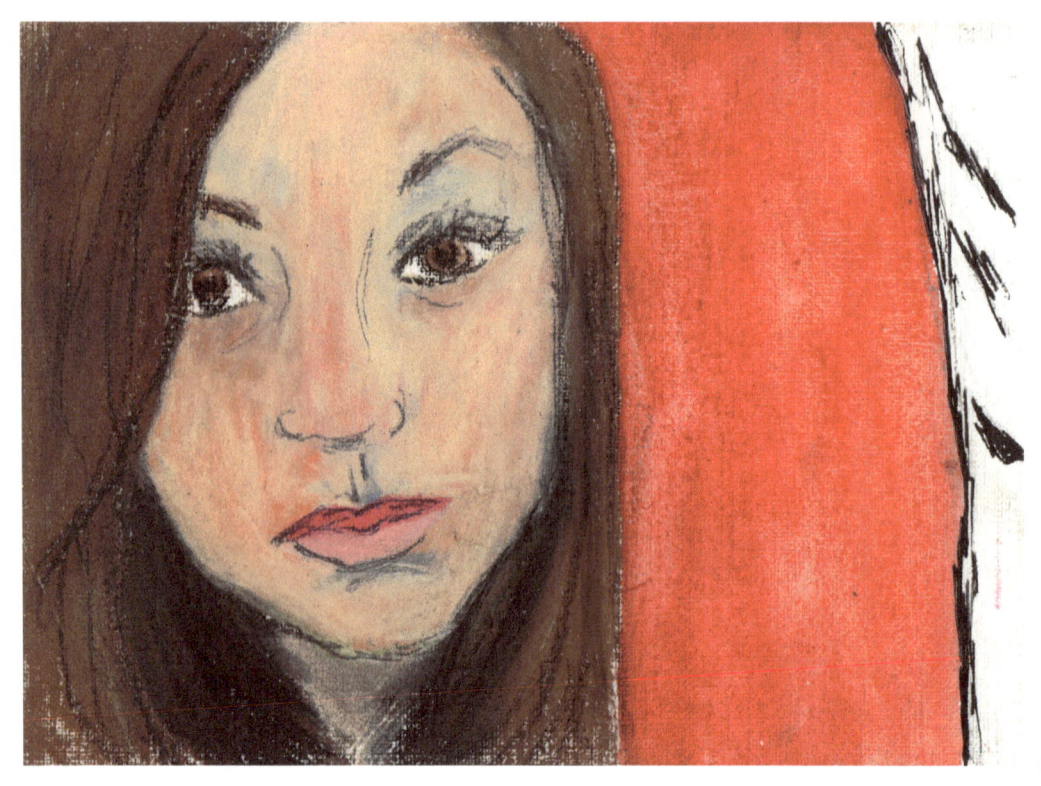

(Fig. 13)

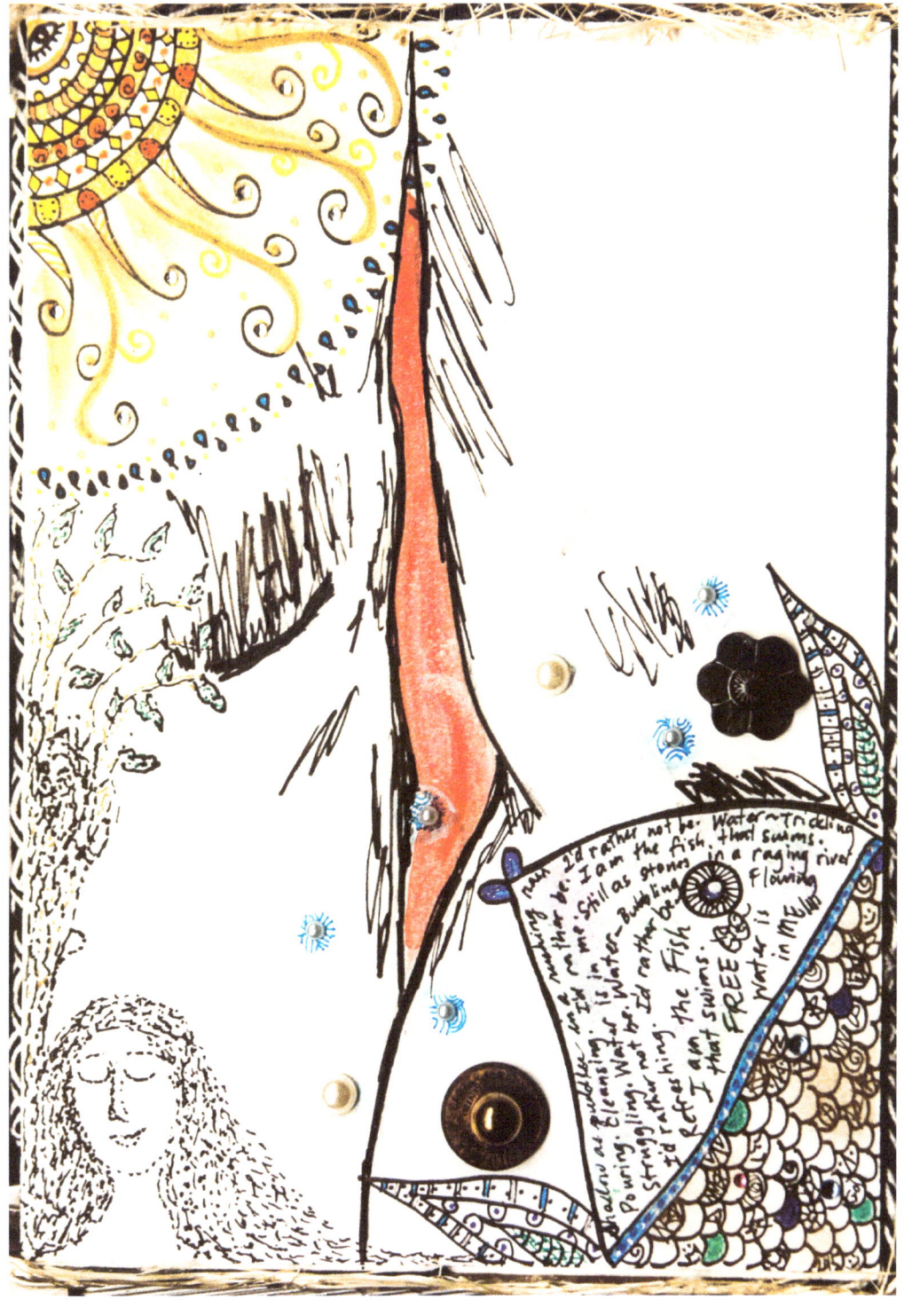

(FIG. 14)

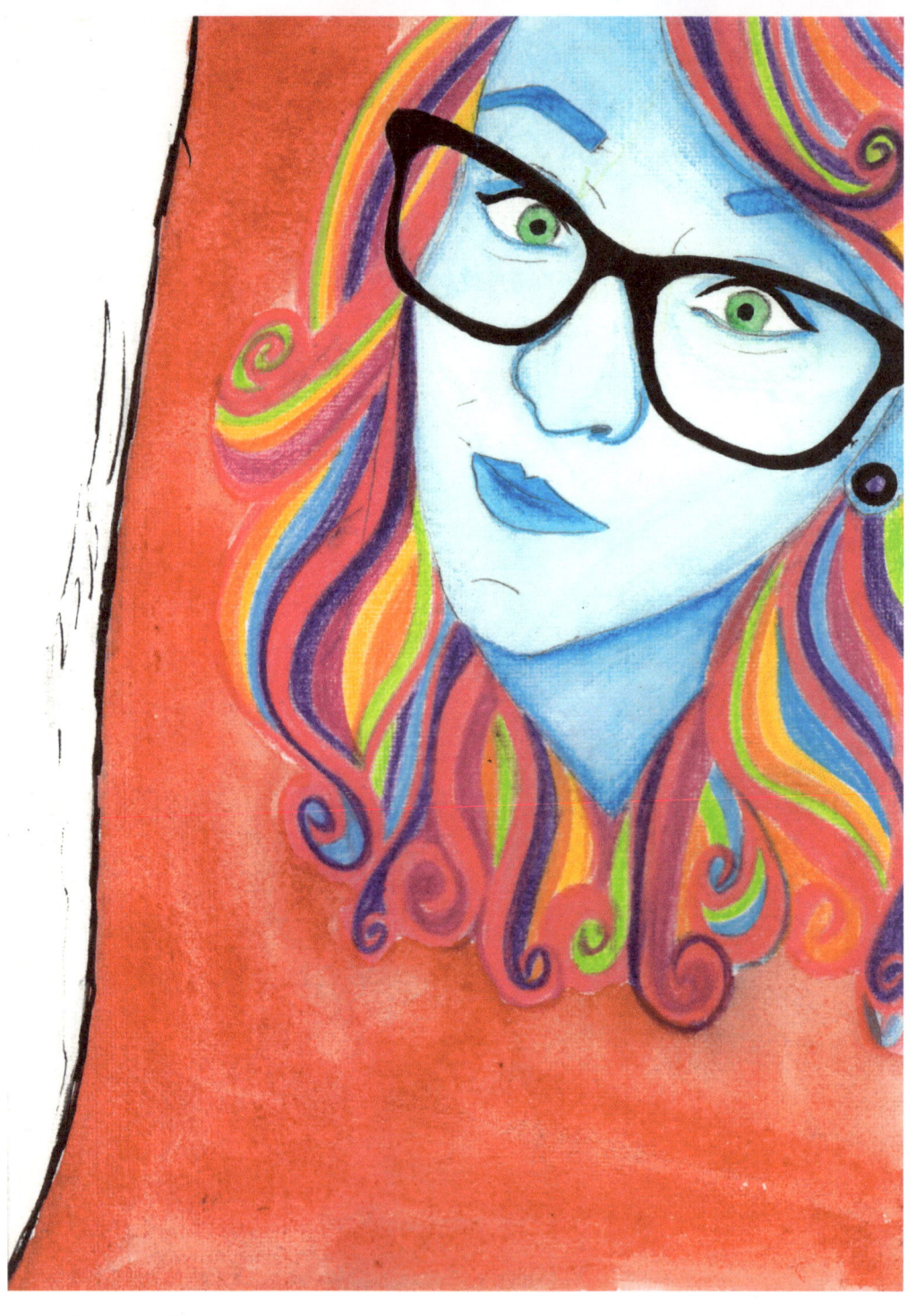

(Fig. 15)

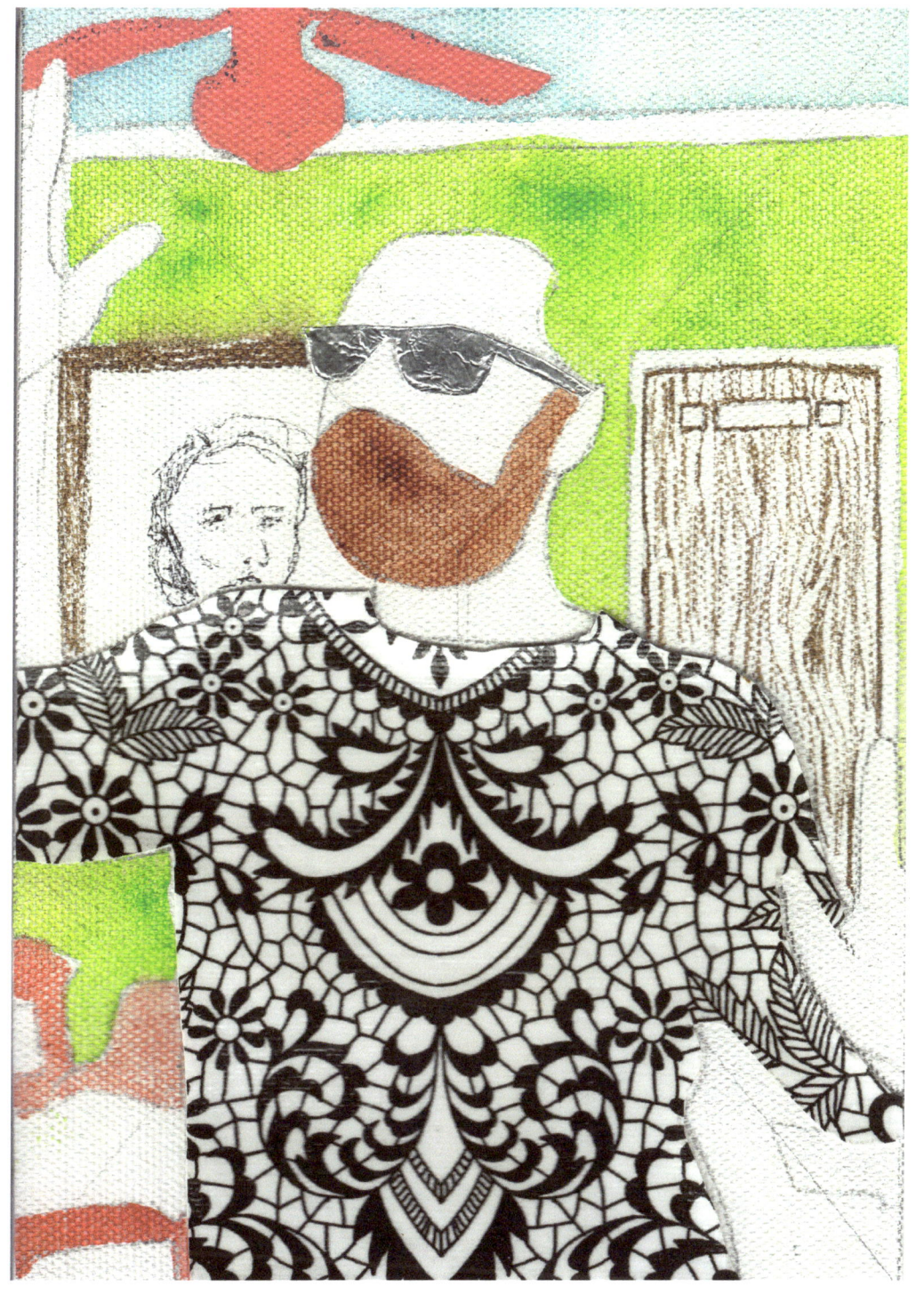

(FIG. 16)

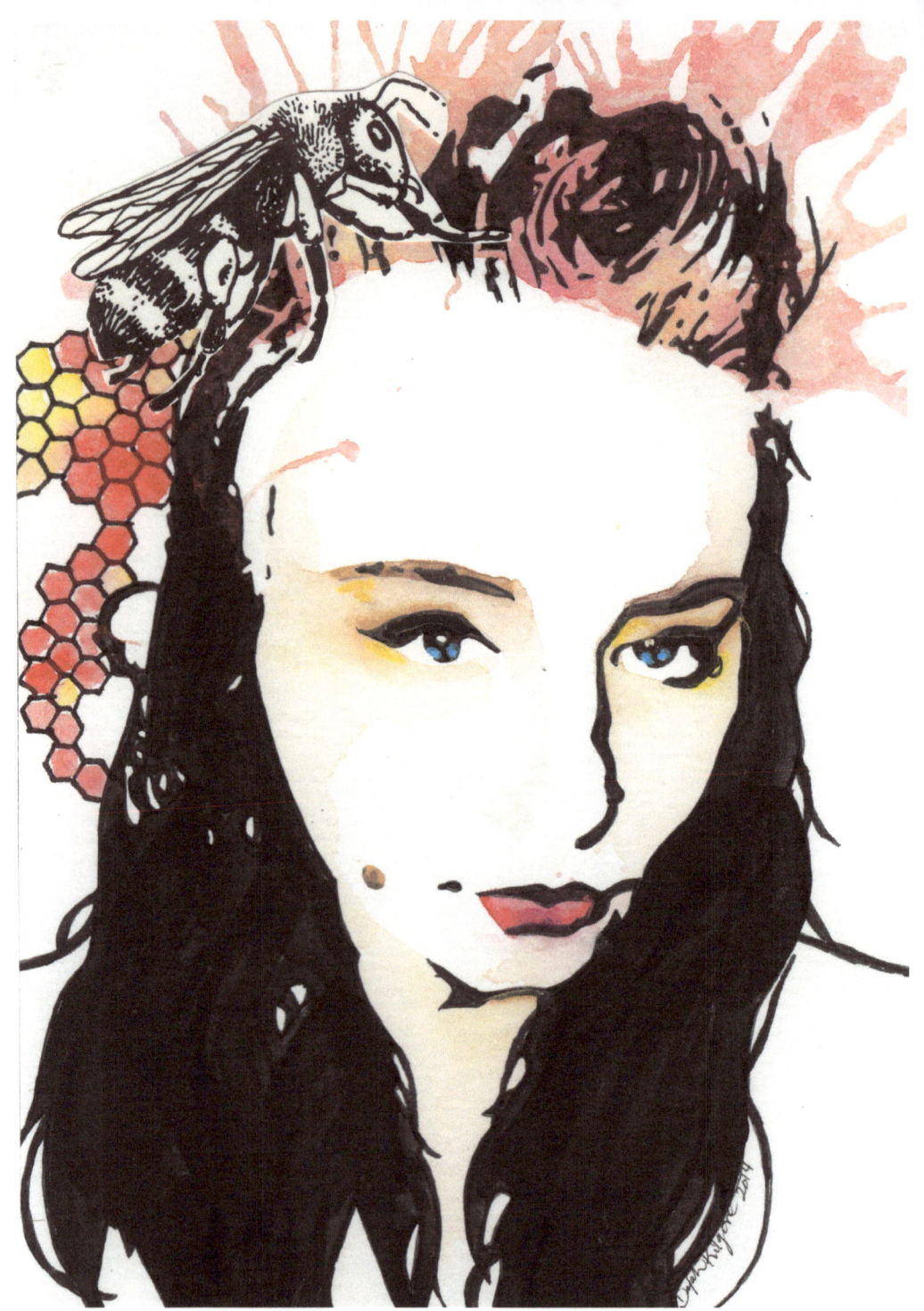

(Fig. 17)

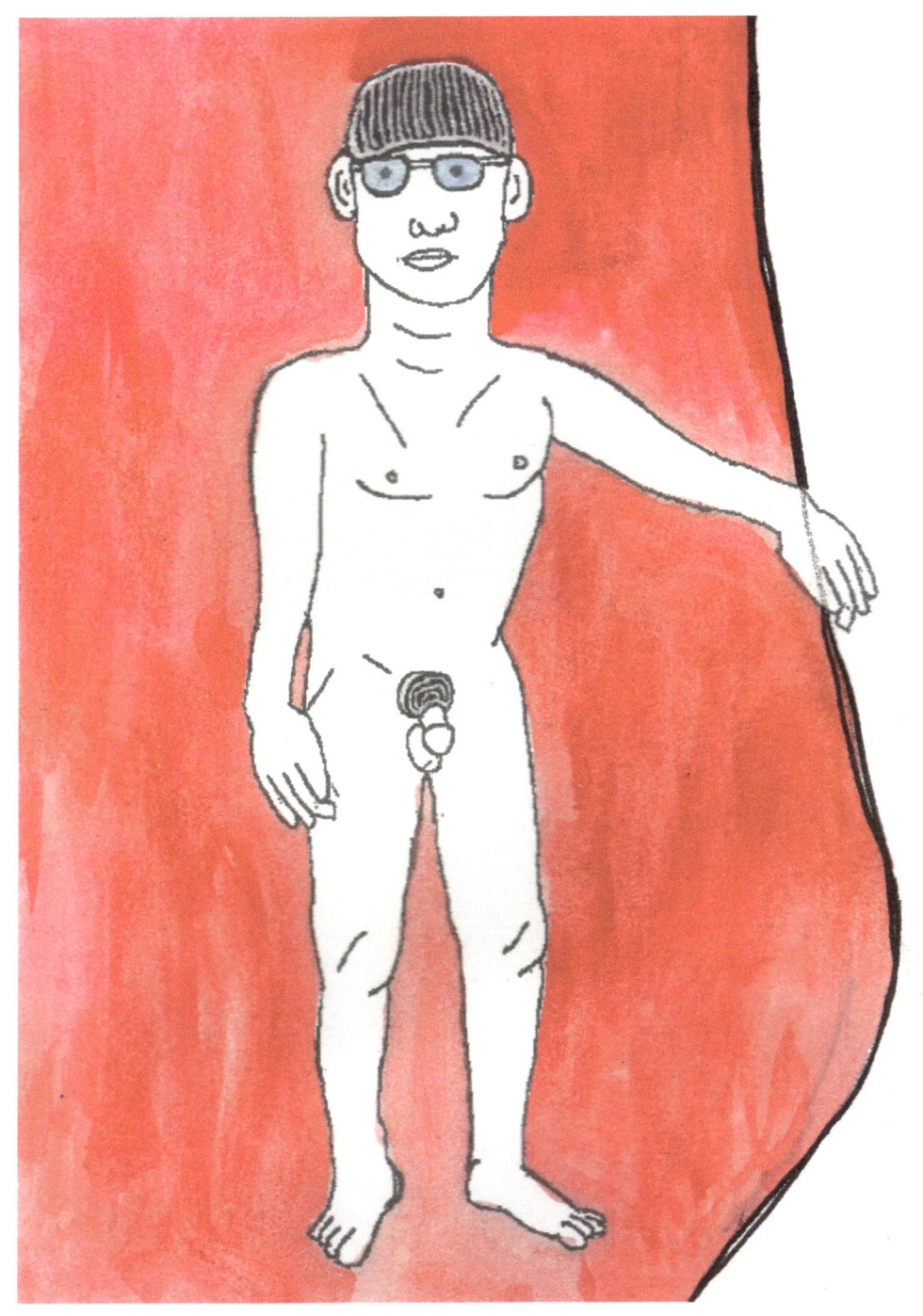

(Fig. 18)

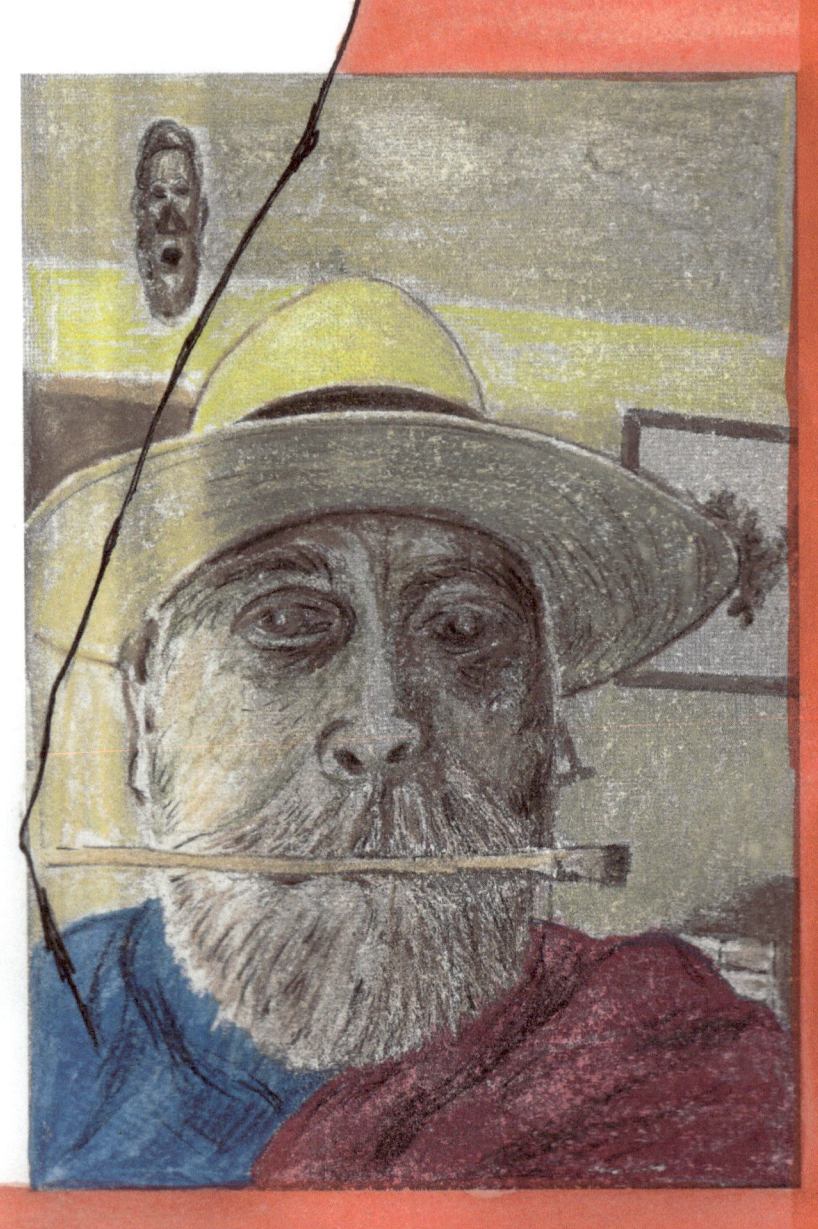

(FIG. 19)

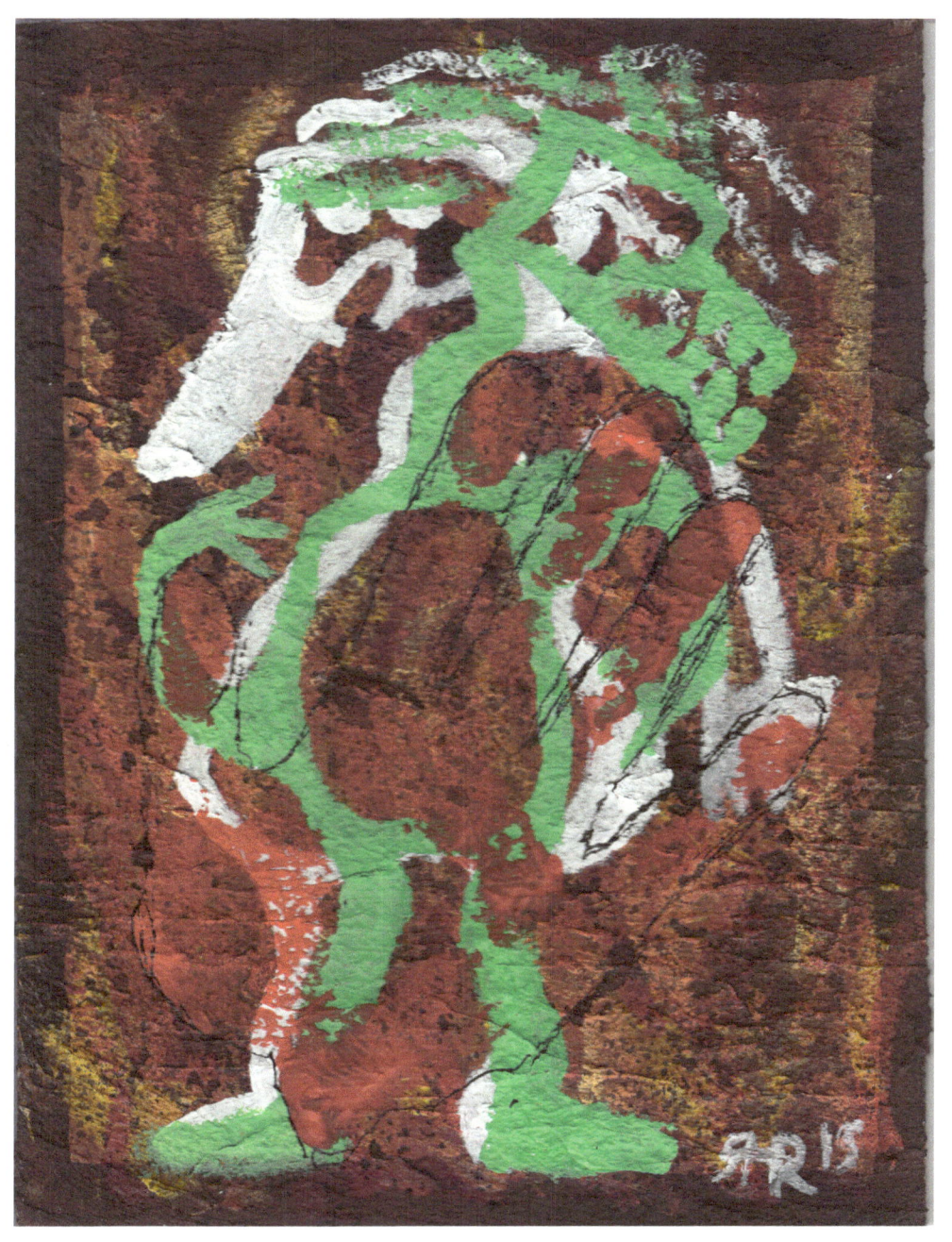

(Fig. 20)

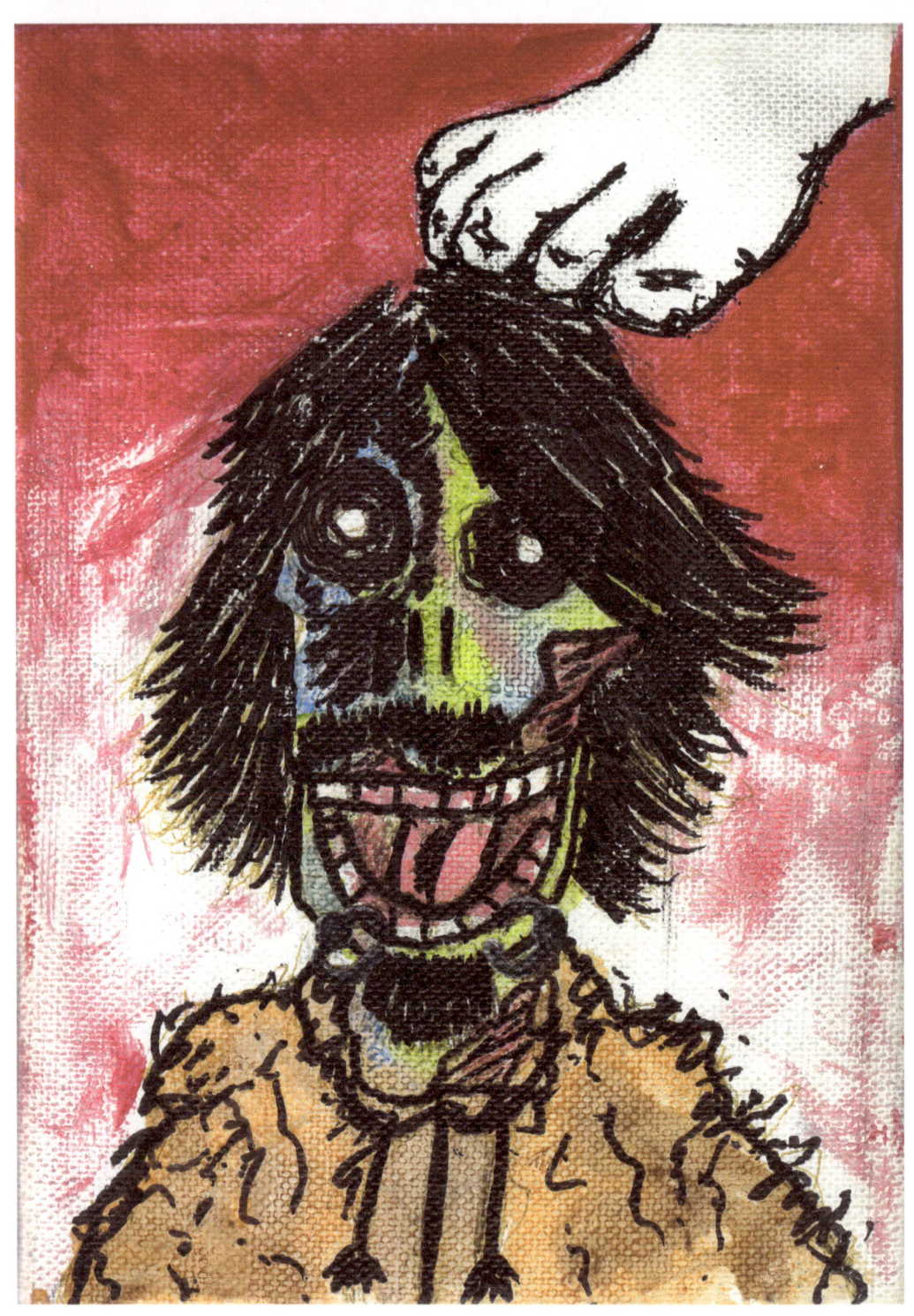

(Fig. 21)

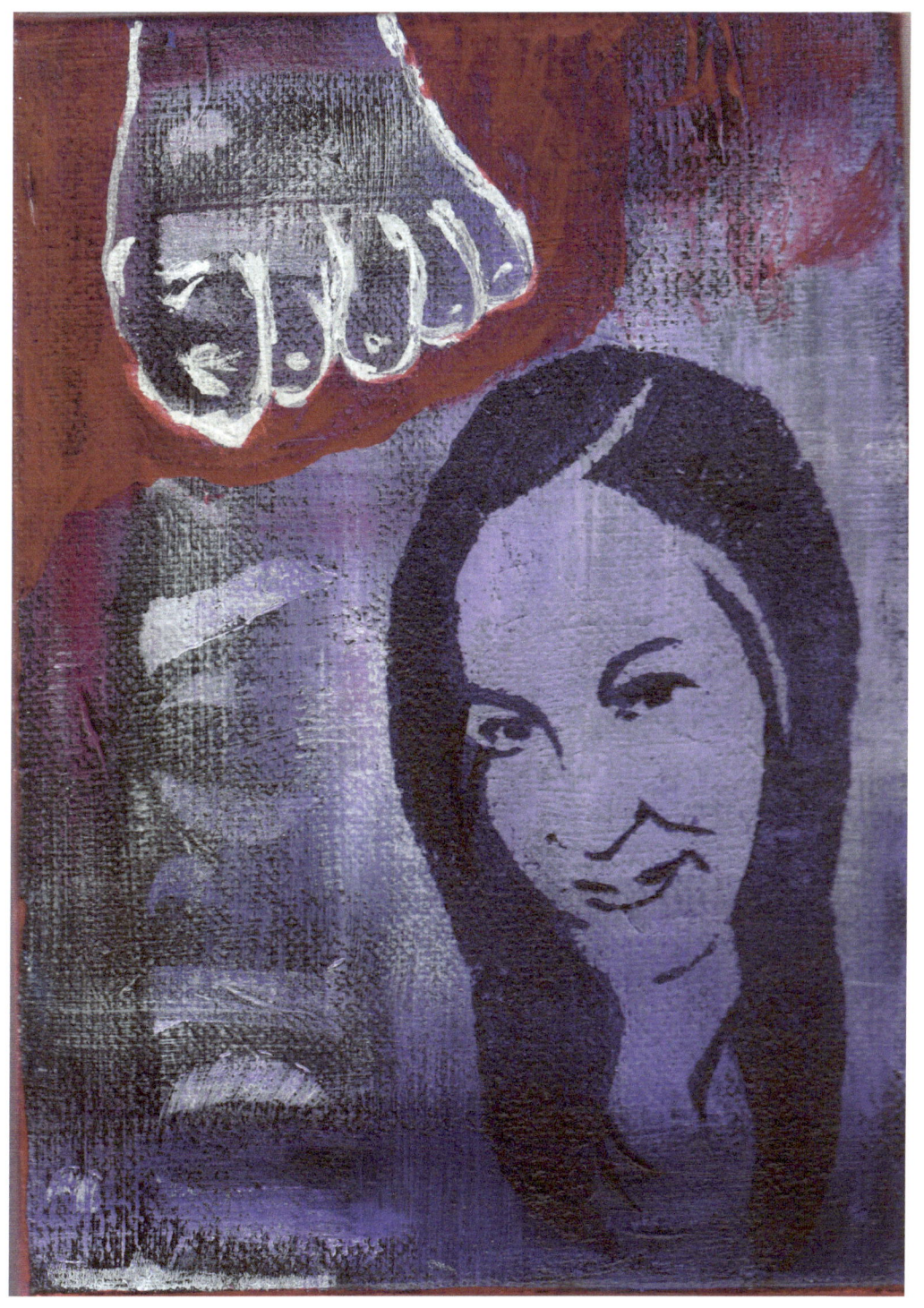

(FIG. 22)

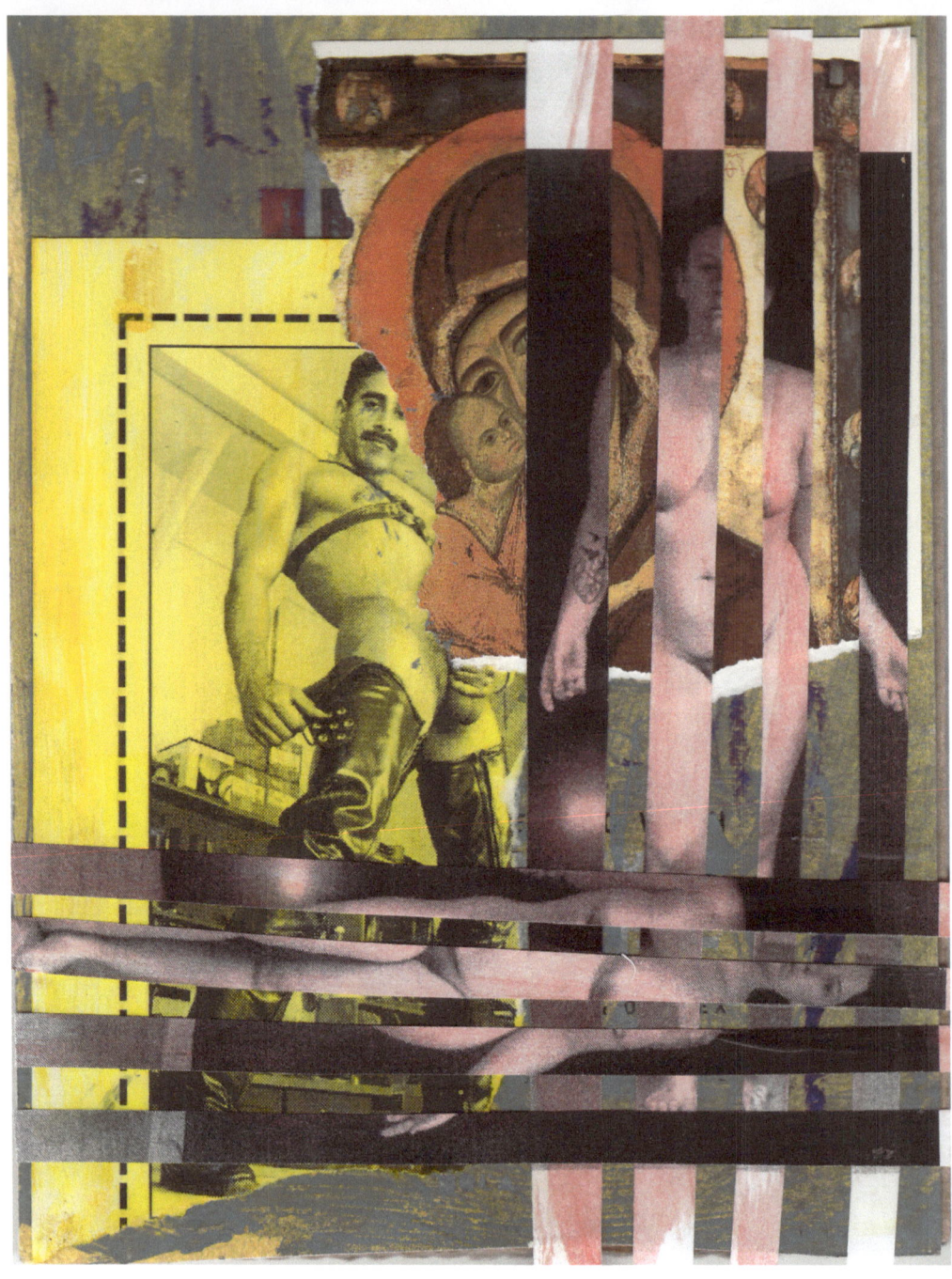

(FIG. 23)

Fig. 1

Collaboration: Eleanor Saad (EAS Artworks), Kristen Iseri & Autumn Steam. Mixed Media: watercolor, marker, pen, acrylic, oil, on paper and transparency. 7x5 in. 2015/16.

Eleanor Saad: (Australia) Easart@hotmail.com, IG: Eas_Artworks, T: Eas Artworks, FB: Eas Artworks

"As a self-taught visual artist, ELEANOR is best known for her timeless intricate style that captivates and inspires an audience. Drawing inspiration from experience, people, breath taking places and even dreams, ELEANOR is fas gaining a following for her signature Black & White ink illustrations. With attention o detail and whimsical feel, each art piece has its own story and open to ones interpretation...

Drawing selfortrait ELEANOR, inspirations of Frida Kahlo, Gustav Klimt & my love of creamy cakes."

Kristen Iseri: (Oregon, U.S.) threads.76@gmail.com

Fig. 2

Collaboration: Rockee Sturges (Rockee Whimsy Art) & Autumn Steam. Mixed Media: Pen, sharpie, glue, acrylic, watercolor, pencil. 5x7 in. 2015/16.

Rockee Whimsy Art: (San Fransisco, U.S.) Rockee1288@gmail.com, FB- Rockee Sturges Whimsy Art
IG: rockeewhimsyart

Fig. 3

Collaboration: Pam Blasko & Autumn Steam. Mixed Media: Paper cutout from 1955 Life mag, page from a vintage book, gesso, distressing, watercolor, zipper, glue, glitter, watercolor pencils, pen, pencil. 5x7 in. 2015/16.

Pam Blasko: (Connecticut, U.S.) pamblasko82@gmail.com

"Born in 1955 this self portrait is me emerging from the past and going into the best years of my life.
Fiber artist is who I have been for the past 20 years. Recently I added mixed media junk journaling to my interest."

Fig. 4

Collaboration: Crystal Burgoyne & Autumn Steam. Mixed Media: Watercolor, pencil, sharpie. 7x5 in. 2015/16.

Crystal Burgoyne: (U.S.) crystal.burgoyne@gmail.com

Fig. 5

Collaboration: Ninna Palmario & Autumn Steam. Mixed Media: Silver sticker paper, ink, mirror, paper on illustration board, sharpie, acrylic. 5x14 in. 2015/16.

Ninna Palmario: (Philippines) palmspix@yahoo.com

Fig. 6
Collaboration: Jami & Autumn Steam. Mixed Media: Marker, Watercolor, pencil. 7x5 in. 2015/16.
Jami: (Oregon, U.S.) webeginbeing.blogspot.com
"I am...
I am an artist.
I am an artist,
Exploring creativity.
I am an artist,
Exploring creativity.
Happy with my life.
I am an artist,
Exploring creativity,
Happy with my life,
Enjoying my time here on earth."

Fig. 7
Collaboration: Linda (Pip) Sisemore & Autumn Steam. Mixed Media: Watercolor, ink, pen, pencil, acrylic. 7x5 in. 2015/16.
Linda Sisemore: (Oregon, U.S.)

Fig. 8
Collaboration: Mardeane Renshaw & Autumn Steam. "Hiding Behind My Glasses" Mixed Media: Acrylic color, pencil, acrylic pen.
Mardeane Renshaw: (Oregon, U.S.) mrenshaw49@gmail.com

Fig. 9
Collaboration: Jaide Hubbard & Autumn Steam. Mixed Media: Acrylic, watercolor and acrylic pen. 5x7 in. 2015/16.
Jaide Hubbard: (Oregon, U.S.)

Fig. 10
Collaboration: Lance Van Valin & Autumn Steam. Mixed Media: Watercolor, pen, acrylic pen, and pencil. 5x7 in. 2015/16
Lance Van Valin: (Oregon, U.S.)
barblance@yahoo.com,
www.facebook.com/artbylance

Fig. 11
Collaboration: Jacob Wolff & Autumn Steam. Mixed Media: Photography print, embroidery thread, marker, acrylic. 5x7 in. 2015/16.
Jacob Wolff: (Oregon, U.S.) https://www.youtube.com/user/jacobwolff88

Fig. 12
Collaboration: Gert W. Knop & Autumn Steam. Mixed Media: Print of an Early Linoleum-print, watercolor, pencil, ink, on paper. 8.5x11 in. 2015/16.
Gert W. Knop: (Germany) ag.1943ze@gmail.com
(See also Fig. 19)

Fig. 13
Collaboration: Brittney Dunn & Autumn Steam. Mixed Media: Firm Pastel Sticks, watercolor, pen, acrylic pen. 7x5 in. 2015/16
Brittney Dunn: (Arkansas, U.S.)

Fig. 14
Collaboration: Nikko Palmario & Autumn Steam. Mixed Media: Board, foam board, pens, sinamy, & things found, oil pastels, acrylic, acrylic pen, watercolor, pencil. 5 x 7 in. 2015/16
Nikko Palmario: (Philippians) chocliq-mail@yahoo.com

Fig. 15
Collaboration: Abbey Denney & Autumn Steam. Mixed Media: Watercolor, acrylic, pencil, acrylic pen on paper. 5 x 7 in. 2015/16
Abbey Denney: (Arkansas, U.S.) IG: FanceFeet_21, FB: FanceFeet21, ETSY: FanceFeet_21

Fig. 16
Collaboration: Zack Kosta & Autumn Steam. "Paint By Numbers" Mixed Media: Watercolor, paper, foil, pencil, pen, acrylic pen, glue on canvas. 5 x 7 in. 2015/16.
Zack Kosta: (Oregon, U.S.) zkosta123@yahoo.com
"Zack Kosta is a Process Artist from Portland, OR. and founder of Craft Night South East, a weekly art event, eight years running. Passion for community driven art is his main focus. Check out Craft Nicht South East on FB."

Fig. 17
Collaboration: Dajah Kilgore & Autumn Steam. "Splat II Self Portrait" Mixed Media: Watercolor, ink, pencil, acrylic pen, ephemera on paper. 5 x 7 in. 2015/16
Dajah M. Kilgore: (Oregon, U.S.) dajahkilgore@yahoo.com, FB:Purrrfectly Flawed Handmade Goods, DEVIANT ART: dajahkilgore.deviantart.com/gallery
"Dajah is a Mixed-Media artist who recently got into Water Colors and Inks after being left a set by her late grandfather, who was an exceptional artist and engineer. Her process brings out the shadows of her subjects so as to render the colors more meaningful. Her work has been shown in various locations around Oregon since the early 2000's. While not formally trained, her natural skills has increased greatly over the years. Her work as a youth with a Portland based group to install murals around the city, has given her a good basis with respect to working with others. When she isn't cooking a late-night Portland hot spot, she can be found at home with her two cats and her husband, creating endlessly."

Fig. 18
Collaboration: Philip Kunz & Autumn Steam. Mixed Media: Watercolor, acrylic, pencil, acrylic pen, and ink on paper. 5 x 7 in. 2015/16

Philip Kunz: (Oregon, U.S.) pilip.kunz@gmail.com
*"I pray, for fashion's word is out
and prayer comes 'round again,
that i may seem, tho I die old
a foolish, passionate man." -yeats*

Fig. 19
Collaboration: Gert W. Knop & Autumn Steam. Mixed Media: Print of an Early Linoleum-print, watercolor, pencil, ink, on paper. 8.5x11 in. 2015/16.
Gert W. Knop: (Germany) ag.1943ze@gmail.com
(See also Fig. 12)

Sea of Oblivion
*I, stone,
I roll far
Well into the infinite
Sea of Oblivion
The time,
It flees before thee,
Eyes closed,
As without light,
and falls
Into the abyss
Like the past.
 by Gert W. Knop*

Biography: *"Gert W. Knop, Pseudonym André Steinbach, born in 1943, studies of art and tropical agriculture in Germany and Scotland (University of Edinburgh). He has lived in many different countries and writes mainly in German, English and Spanish. He is a published writer and received first prizes in art (Michotouchkine-Prize and PITCo-Prize in Port Vila, Vanuatu) and also prizes for his poetry and short stories. He currently resides in Zittau (Saxony), Germany."*

Fig. 20
Collaboration: Mike Adamson & Autumn Steam. Mixed Media: acrylic, acrylic pen on board. 8 x 10 in. 2015/16
Mike Adamson: (Oregon, U.S.) FB: Michael Adamson

Fig. 21
Collaboration: Cheylan Edison & Autumn Steam. Mixed Media: acrylic marker, pencil, acrylic pen on canvas. 5 x 7 in. 2015/16
Cheylan Edison, Unique Perception Arts: (Washington, U.S.) uniqueperceptionarts@gmail.com, ETSY: Unique Perception Arts, FB: UniquePerceptionArts, http://uniqueperceptionarts.tumblr.com/

Fig. 22
Collaboration: Girlspit Art & Autumn Steam. Mixed Media: Stencil, acrylic, spraypaint, acrylic pen on canvas. 5 x7 in. 2015/16.
Girlspit Art: (Washington, U.S.) girlspitart@gmail.com, ETSY: Girlspit Art,

TUMBLR: Girlspit Art, FB: Girlspit Art

Fig. 23
Collaboration: Luka Fisher & Autumn Steam. Mixed Media: acrylic, acrylic pen, ephemera, glue, and watercolor on cardboard. 5 x 7 in. 2015/16
Luka Fisher: (California, U.S.) www.luka-fisher.com
"I am part of a long chain
thats been cut up
in the presence of the possible.

No separate self; just an echo
here to lead the broken hearted. "

A note from Autumn:

I want to thank everyone who participated in this second Artist's Shuffle. This project was started back in 2015 right before I had a series of personal crisis that caused a huge amount of growing and learning. As I sit down to write this today, I can say I am a far healthier, balanced and aware person. In 2015, I gave up all of my art businesses to homeschool my two children. Shortly after, my tribe went through a mass overhaul, leaving me to rely totally on myself. This pressure was too much stress for me and so I quit making art and tried to be there for my kids. As you can imagine, an artist can never "quit art", and so it began calling me again. At the beginning of 2016, I started my renewal by getting my body and mind in shape. I knew if I was going to be a good artist, I needed to become more informed and balanced. On January 8, 2016, I began a 6 month struggle, going to the gym 5 days a week and completely overhauling my diet. I broke bad habits, created good ones and lost over 50 lbs. In June, we decided to move and in July I started my second Bachelor's Degree program at SNHU in Graphic Design. We officially moved into our new home on an acre in Oregon in December 2016, and I am projected to graduate with my degree by the end of this year.

I am generally a very private person and so the hardest part about this project was understanding what my dichotomy means to me. Every time I thought about it and went to create my visual representation for this collaboration, it seemed too small or disappointing. It was only after I lost the weight and I began to build my self confidence back that I could see what I wanted to create. I realized that I wanted this project to be about all of me. My dichotomy. My opposites, all of my good and bad. To me nothing speaks the truth more than being naked. So I laid out all 23 art pieces and sketched, painted and put a little bit of myself in each one.

As these are shuffled and passed on to new collections, I hope you reflect on your dichotomy and embrace it.

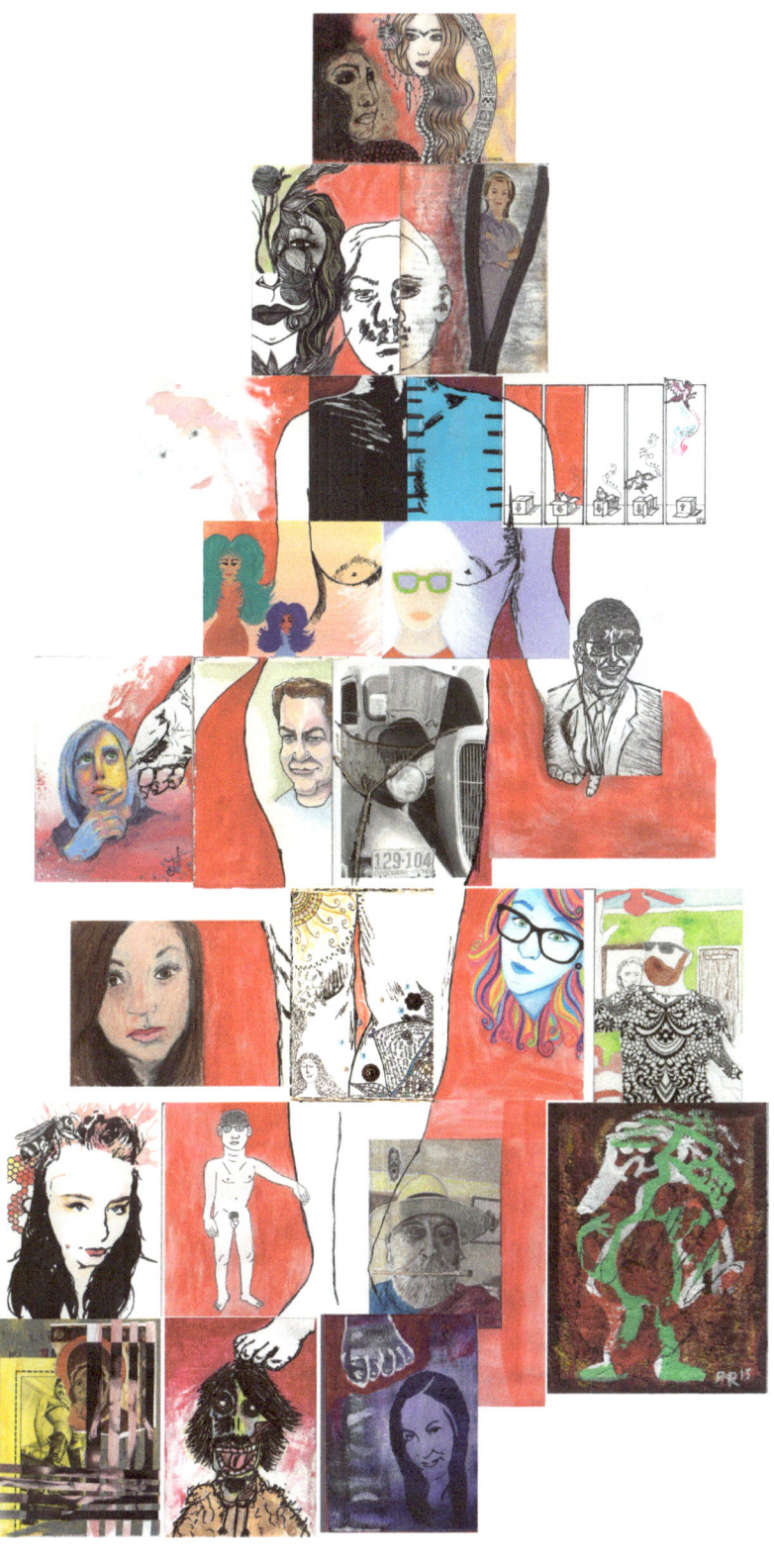

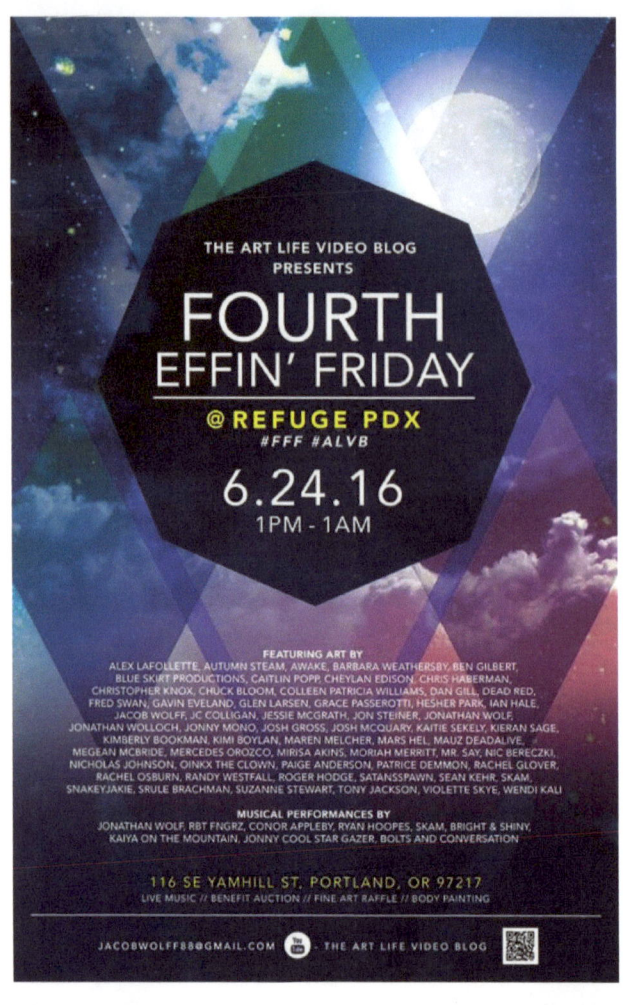

Huge thanks to Fourth effin' Friday and Jacob for letting us show at this event!

6-24-16
@Refuge PDX
Portland, OR, US

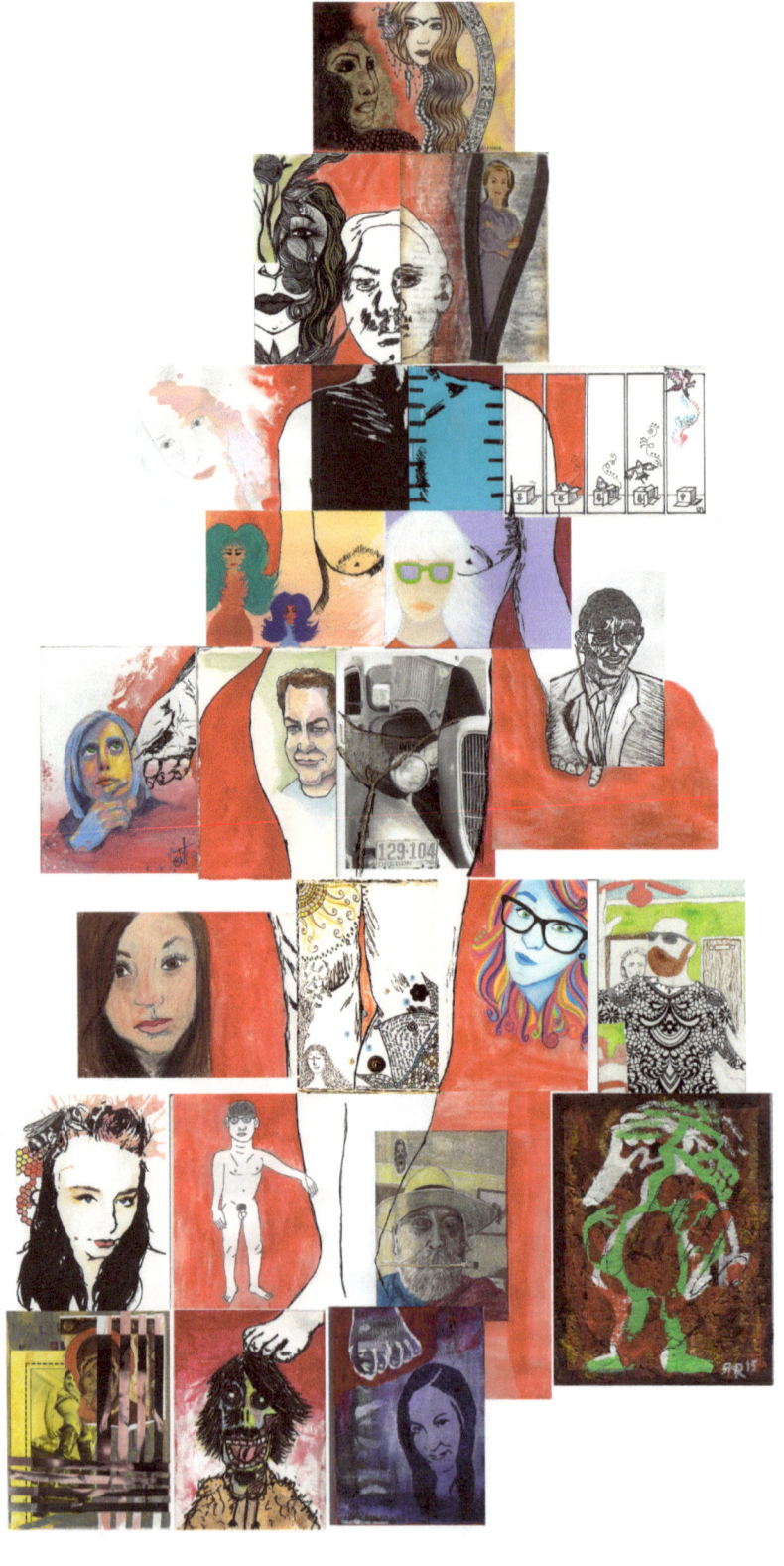

www.ingramcontent.com/pod-product-compliance
Lightning Source LLC
Chambersburg PA
CBHW041116180526
45172CB00001B/282